Canton Enamel:

The Charm of Export Porcelain

Elegant Guangdong Series Editorial Board

Paths International Ltd

南方日报出版社
NANFANG DAILY PRESS

CONTENTS

Refulgence
Process Features

The Inextinguishable Kiln Fire
Inheritance of Cherished Value

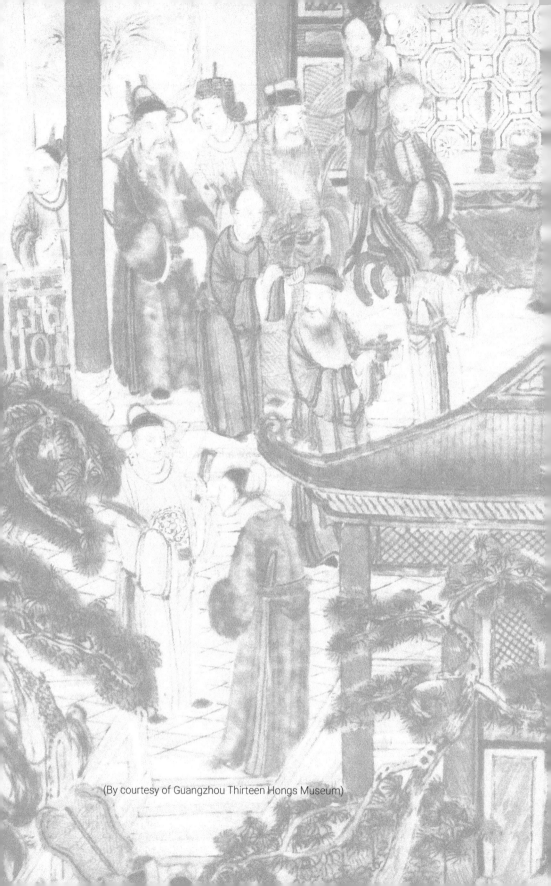

(By courtesy of Guangzhou Thirteen Hongs Museum)

Foreword

More than 270 years back in time, the homebound Swedish merchant ship Göteborg I set sail from Guangzhou on January 11, 1745. Unfortunately, Göteborg I wrecked and sank when it was about to approach its destination port. On board the ship were about 700 tons of tea, chinaware and silk, etc. from China. Among the chinaware went under, a substantial portion were world-famous "Canton enamel" articles.

China has long enjoyed the repute of "the country of chinaware", and its namesake commodity won it world renown. Born in the Qing Dynasty, Canton enamel stands out distinctly in China's millennium-long history of porcelain development. Canton enamel, short for Canton painted porcelain or Canton gold brocade enamel, is a specialty chinaware with color painting on glaze unique to Canton. It arose on the need for export, integrated the essence of Western and Chinese techniques. Since the first firing during the reign of emperor Kangxi, it had crossed the seas and oceans, endeared itself to countless clients across the world. It has since become one of the brightest cultural cards on the Maritime Silk Road.

Foreign merchant ships in Whampoa Anchorage

In its incipient stage, Canton enamel mainly engaged in a practice of applying enamel on baked white chinaware which had been shipped in from other places. Having been shipped from Jingdezhen to Guangzhou by Canton merchants, the white chinaware were first subjected to a series of enamel painting and baking processes, and then shipped abroad. Canton enamel articles swept Europe and fascinated the people. During the reign of Qianlong period, after the American merchant ship Empress of China made its successful maiden voyage, Canton enamel gradually shifted its market focus from Europe to the United States. Extensive employment of gold brocade patterns began to find its way into decorative style of the craft, as though thousands of gold thread knit round fair jade. In the period from the late Qing Dynasty to the founding of the Republic of China, craftsmen of Lingnan Painting School including Gao Jianfu attempted to adopt new techniques and motifs into the production of Canton enamel, which breathed new life into the technique of Canton enamel.

After the founding of the People's Republic of China, Canton enamel inherited the tradition and embarked on a road of innovation and diversification. After the turn of the 21st century, this traditional skill gained a brand new identity. In 2008, the Canton enamel porcelain baking technique was included in the second batch of national intangible cultural heritage list, which turned over a new leaf in its conservation, inheritance and development.

Having gone through more than 300 years of history, Canton enamel has been on top of the world and also been stuck in slump. This book will walk you through the past and present of Canton enamel, bring you home the craft of fire and clay of the "stacking gold and weaving jade", and help you appreciate the grace of Guangdong which boasts long historical tradition.

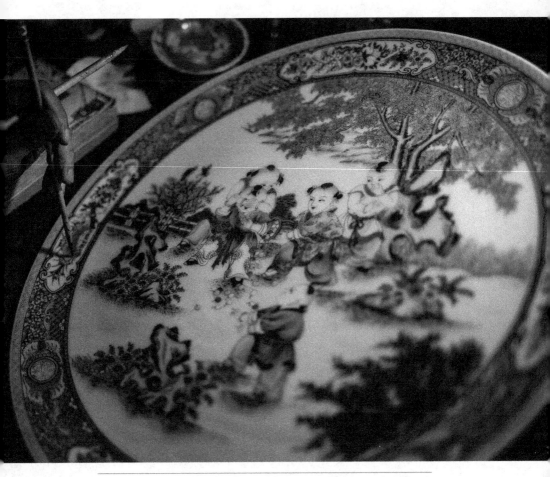

A craftsman of Guangzhou Zhijin Painted Porcelain Factory makes Canton enamel in the workshop

The Treasure on the Maritime Silk Road

Past and Present

Origin
Trade and Popularity of Canton Enamel
across the World

Evolution
Ingenuity and Innovation for Transcendence

Origin

Trade and Popularity of Canton Enamel across the World

Originated in trade between China and the West

The prosperous commerce and trade has made Guangzhou a major trading port for China's porcelain exports since ancient times. Its favorable foreign trade conditions have contributed to the birth of Canton enamel, while the One-Port Trade policy instituted by the Qing government has facilitated the prosperity of Canton enamel.

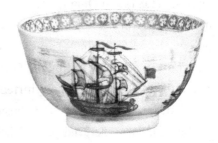

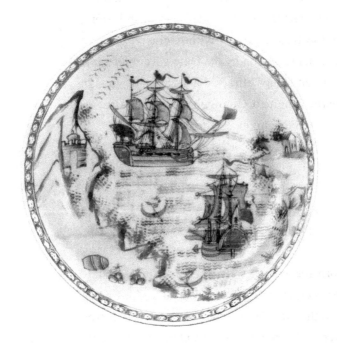

Small cup and dish with the design of ships (by courtesy of Guangzhou Thirteen Hongs Museum)

9

In the 23rd year of Kangxi period of the Qing Dynasty (1684), the Qing government lifted the marine trade ban and implemented open-sea trade policy. In the following year, the Guangdong Customs was established in Guangzhou. Since then, Thirteen Hongs (thirteen trading firms) dedicated to foreign trade business were established. Form the 22nd year of the Qianlong period of the Qing Dynasty (1757) to the outbreak of the Opium War (1757–1842), Guangzhou had monopolized foreign trade and it had been known as "One-Port Trade" system in history. As the trading firms with exclusive foreign trade authorization by the Qing government, the Thirteen Hongs attracted a great many foreign businessmen to Guangzhou, which directly promoted the production and sales of handicrafts from Guangzhou for export. These handicrafts integrating Chinese and Western skills and styles were important witnesses of cultural exchanges between China and the West, while Canton enamel is an outstanding example of them.

Born for export, Canton enamel immediately became the darling in the maritime silk trading road the moment it came into existence. It won over the heart of the world and became a favored article in the houses of European royal families and nobles. According to historical records, the family of Newton, the scientist, and the Russian emperor Catherine the Great both had owned Canton enamel armorial porcelain.

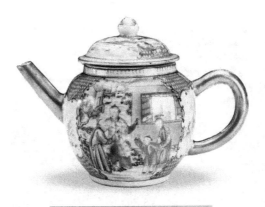

Porcelain teapot with figure painting

| Originated in Jingdezhen ceramics

Early Canton enamel was not drastically different from painted porcelain for export made in Jingdezhen, the famous porcelain city. Regarding the source of the technology of Canton enamel, industry-wide legend has it that it had been introduced during the Kangxi period by Yang Kuai and Cao Kun, two painted porcelain craftsmen from Jingdezhen. Having moved from Jiangxi to Guangdong, Yang Kuai and Cao Kun used the porcelain painting techniques they mastered to draw some porcelain for sale, and their painted porcelain were deeply loved by foreign customers, hence their products were often in short supply. So the two expanded the scale of production and bought white glazed porcelain from Jingdezhen of Jiangxi and shipped such to Guangzhou for further painting. They also set up workshops and recruited apprentices to disseminate painting technique. This was the inchoate form of Canton enamel.

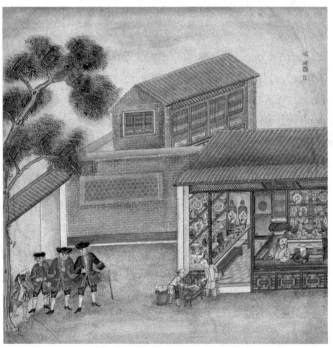

| Painted in South of the Pearl River

According to memories of Canton enamel craftsmen, Canton enamel production workshops in the Qing Dynasty were initially concentrated in a couple of places including areas around Hualin Temple and Changshou Temple in the west of Guangzhou, that is, the north of the Thirteen Hongs. In the 43rd year of Qianlong period (1778), the "Lingsi Hall" of Canton enamel guild was established. It was originally located in Yugui Third Alley next to Hualin Temple, and was demolished during the time of Resistance War against Japanese. Later, Canton enamel workshops were relocated to areas including Longdaowei village and Longtian village on the south bank of the Pearl River; hence Canton enamel is also known as "painted porcelain of the south Pearl River bank". Until the early 20th century, Canton enamel workshops were still concentrated on an island on the south of the Pearl River, and they were moved in great number to Hong Kong and Macao after the end of the War of Resistance against Japanese. After the founding of the People's Republic of China, when Guangzhou established the Guangzhou Zhijin Painted Porcelain Factory, Canton enamel returned to Guangzhou.

Two illustrations in the "Porcelain Production and Transportation", which depict the export of porcelain in Jingdezhen in the Qing Dynasty in the 18th century (above) and the activities of foreign businessmen in Guangzhou (below)

Evolution

Ingenuity and Innovation for Transcendence

Start-up
No Fixed Form Every Year

The Kangxi period and Yongzheng period of the Qing Dynasty were the initial stage in the development of Canton enamel porcelain. The earliest record of the production time of Canton enamel porcelain was from the Kangxi period, when French King Louis XIV dispatched people to Guangdong to place order for the painted porcelain. The earliest Canton enamel items found in China is a consecrated figure vase of Canton enamel made in Yongzheng period of the Qing Dynasty.

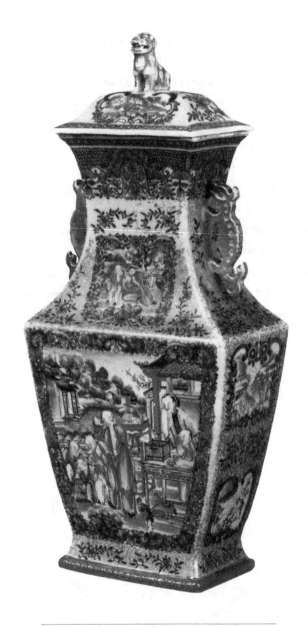

Square vase with the design of figures traced in gold
(by courtesy of Guangzhou Thirteen Hongs Museum)

In its early stage, Canton enamel was similar to Jingdezhen painted porcelain, and had not yet formed its own style. With the introduction of Western enamel craftsmanship to China, Guangzhou craftsmen quickly mastered this craft and pigments and applied them to porcelain painting to meet the need of the export market. After incorporating the new technique, Canton enamel began to take on its own characteristics, displaying a different workmanship from Jingdezhen's painted porcelain.

During the Yongzheng period, as export sales gradually expanded to a substantial scale, a large quantity of customized sets of tableware, tea chinaware, and coffee chinaware on orders appeared. The evolution of European taste for art directly affected the demand for tailor-made products in foreign trade, Canton enamel entered the era of "Variegated Styles and Ingenious Crafts, Each Displaying Their Respective Strength".

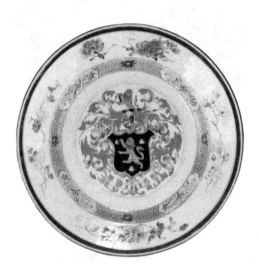

Heraldic porcelain plate

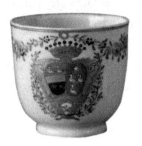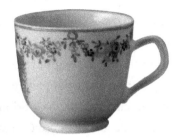

Floral heraldic coffee cup

Heyday
Brilliant and Gorgeous Coloring

During the Qianlong period of the Qing Dynasty, Guangzhou became a metropolis of international trade. Canton enamel became the mainstream variety of painted porcelain for export. It had been all the rage in Europe, and foreign merchants came to Guangzhou to place customized orders for painted porcelain. Many European royal families and nobles around the time of Qianlong period were Canton enamel's "diehard fans". They were keen on collecting and using Canton enamel, and they became fashionable for the time. In the era when Canton enamel was in vogue, there were dozens of porcelain agents in Guangzhou exclusively dedicated to making customized private armorial porcelain for European aristocrats.

17

The Canton enamel produced during the Qianlong period is called "Qianlong Painted Porcelain". Canton enamel of this period gradually took on a distinct character of its own. In terms of painting techniques, it obviously adopted the perspective and color preference of Western paintings, with strong colors and fine workmanship also employed. The ornamentation combined Chinese and Western features; there were both "mandarin" patterns representing Chinese themes and pictures depicting western customs or patterns imitating Western block print and oil painting. The form of the vessel imitated the shape of Western utensils such as silverware.

Turning point
Gradually Becoming An Established Norm

In 1784, the American merchant ship "Empress of China" arrived in Guangzhou from New York, opening up a new chapter in Sino-US trade and also bringing about an important turning point in the history of the development of Canton enamel. The time the Sino-US trade commenced, the European porcelain industry just emerged, which reduced demand for Chinese export porcelain. The emerging American market therefore replaced the European market and became the main market of Canton enamel, which also initiated the transformation of the workmanship style of Canton enamel.

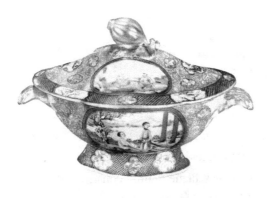

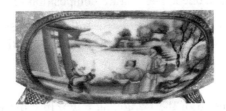

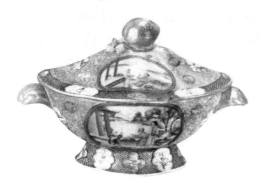

Covered tureen with the design of figures and stories traced in gold
(by courtesy of Guangzhou Thirteen Hongs Museum)

During this period, the artistic style of Canton enamel followed the bright gold tones of popular decorative trend in America. The overall color scheme mainly consisted of bright red, bright green, and bright gold, and gold color was used extensively, which can be justifiably described as "stacking gold and weaving jade." In terms of ornamentation, the main themes were Chinese human figure, Chinese landscapes, and flower and bird patterns. The skills and styles called "figures drawn with color filled on a sketch", also known as "Painted Porcelain of the Jiaqing Period", were also developed. The picture composition of such objects features full, intricate and sophisticated ornaments, resplendent and variegated style. It has been the highly distinctive feature of Canton enamel to date.

Since the period of the Daoguang reign, in order to meet the needs of the export market, Canton enamel entered the stage of mass production, followed by a gradually fixed style, and the painting technique was also relatively fixed, which meant that Canton enamel has no longer been featured as "variegated styles and ingenious crafts, each displaying their respective strength".

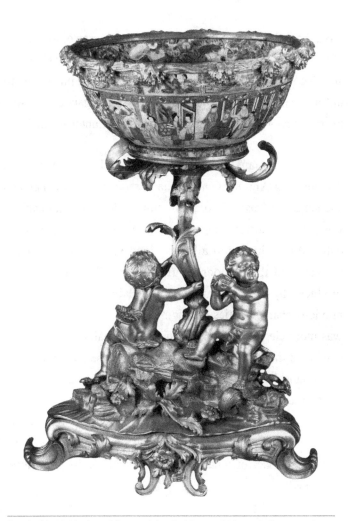

Bowl with the design of figures inland with angel-shaped gilt copper base
(by courtesy of Guangzhou Thirteen Hongs Museum)

New look
Seeking Change through Exploration

From the end of the Qing Dynasty to the beginning of the Republic of China, the Lingnan School Painting, represented by Gao Jianfu and Chen Shuren, incorporated the techniques of Chinese painting in Canton enamel production with fresh and elegant colors, which injected new vitality into the development of Canton enamel.

At that time, Gao Jianfu, Gao Qifeng and others formed the "Guangdong Antique Commercial Association" in Guangzhou, and set up an "artistic porcelain kiln" inside the organization. It was put up as a workshop engaged in Canton enamel production ostensibly, which actually provided support and cover for activities of the democratic revolution. The Canton enamel produced by the Lingnan School of Painting shifted from the previous characteristics of bright color delineation, and its tone was more elegant and pastel. In terms of painting technique, it combined that of the fine arts with that of the painted porcelain craftsmanship. It also adopted the composition and brushwork of the Chinese painting, and the picture looked all the more fresh, elegant and idyllic. The themes were also groundbreaking, with some displaying literati hermits, landscapes, animals, etc., while there was no lack of content to alert the world of the contemporary social evils.

In 1915, 150 pieces of porcelain quivers titled "Twelve Kings Hitting the Ball" created by Gao Jianfu's student Liu Qunxing appeared for the first time at the Panama Pacific International Exposition and won award, which significantly enhanced Canton enamel's international reputation, and export volume for the product shot up at the time.

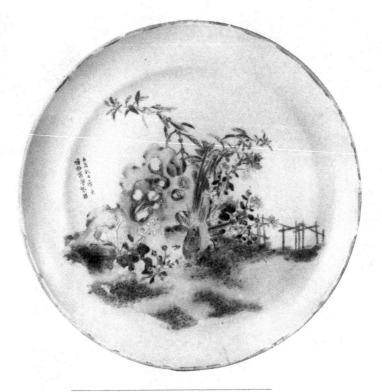

Dish with design of flowers, birds and stones
(by courtesy of Guangzhou Thirteen Hongs Museum)

Refulgence

Process Features

Pigment
Resplendent Handwork of Colors

Ornamentation
Graceful Fusion of
Western and Chinese Styles

Technique
Gorgeous Scenes out of
Sketching, Tracing and Filling

Pigment

Resplendent Handwork of Colors

The gorgeous color combination of Canton enamel comes from the careful preparation and blending of pigments. In the long-term evolution, Canton enamel has gradually developed a pigment preparation system that could not only maintain the ancient colors of Chinese tradition, but also integrate the colors of Western enamel. It can handle painting style of different forms and types.

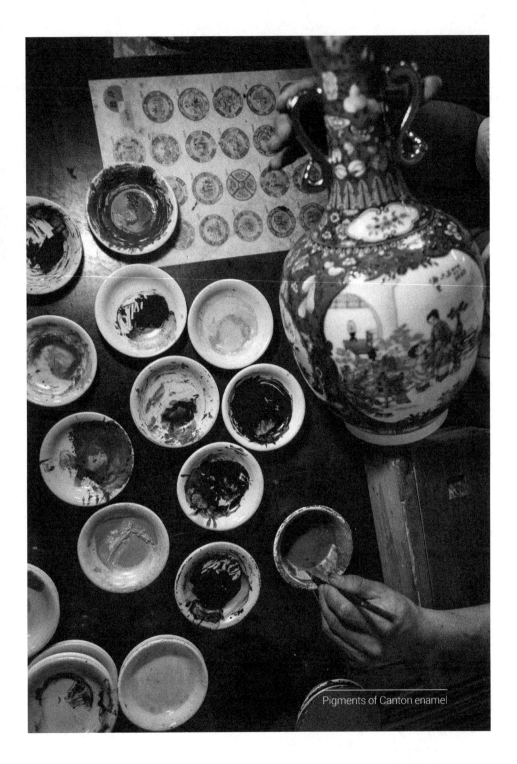

Pigments of Canton enamel

Due to different pigments used in different periods, the luster of Canton enamel also differed. During the Kangxi period, enamel materials and technology had just been introduced into China from Europe. Craftsmen tried to add enamel materials to the traditional five key pigments, but failed to make any substantial difference in terms of developing its own characteristics. The color tone was simple, mainly based on red and green. During the Yongzheng and Qianlong periods, China had domestically developed enamel materials, while Guangzhou became the most important source for domestically-made enamel pigments. Canton enamel craftsmen prepared pigments for Canton enamel with distinctive enamel texture by employing raw stones and pigments shipped in from Europe, so the color prepared were stately and steady.

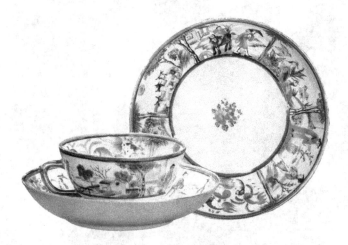

Canton Enamel small cup and dish with figure paintings
(by courtesy of Guangzhou Thirteen Hongs Museum)

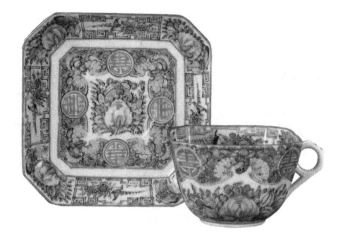

Cups and saucers with the design of flowers, birds and Chinese character " 壽 " (longevity) (by courtesy of Guangzhou Thirteen Hongs Museum)

After the Daoguang period, Canton enamel pigments began to evolve, yellow pigments emerged in large quantity, and application of the golden color doubled. These pigments were capable of producing warm color tone, showing the resplendent, colorful and gorgeous artistic features. After the Guangxu reign, pigments used in Canton enamel were basically foreign pigments and foreign gold color. The pigments could bring about an effect of bright and rich color effect, which became a highly distinctive feature of Canton enamel.

Ornamentation

Graceful Fusion of Western and Chinese Styles

The traditional Canton enamel decorations are diverse in content and cover a wide range of subjects, such as human figures, flowers, fruits, landscapes, birds and beasts, and heraldry. Canton enamel decorations integrate Chinese and Western painting styles, complex without getting messy. It combines both the characteristics of traditional Chinese painting and the artistic essence of Western painting.

Human figure pattern is the most numerous in Canton enamel decorative patterns, including Chinese and Western figures. They are unique in drawing techniques and are mainly embodied in figures drawn with color filled on a sketch, figures drawn by combining color filled on a sketch and coloring color blocks and hollowed-out figures, each with distinctive characteristics of the times.

Armorial porcelain refers to the custom-made export porcelain with emblems painted for royal families, nobles, and companies in Europe and the United States. These emblems mean power, position, and social identity, and are a symbol of glory of the customer. Armorial porcelain is generally regarded as the category of best quality and highest degree of customization among export porcelain.

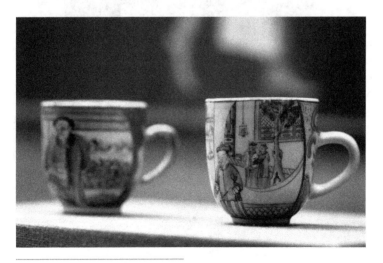

Canton enamel portrait handled cups

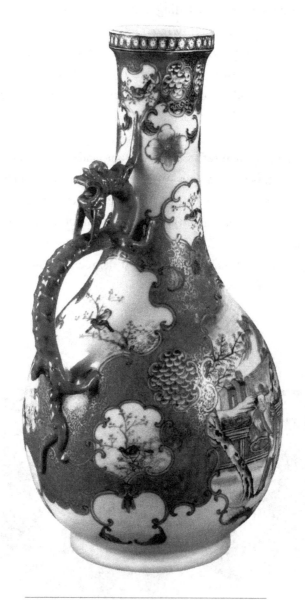

Vase with the design of figures over a brocade ground
(by courtesy of Guangzhou Thirteen Hongs Museum)

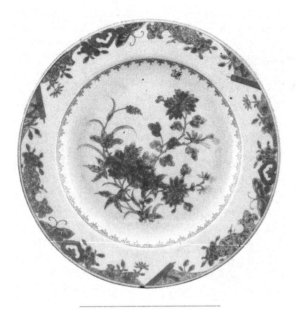

Plate with the design of flowers

The traditional fancy style is of relatively fixed composition that Canton enamel has followed, mainly including brocade human figure, flower and bird, green cabbage, butterflies, and dragon hovering in the cloud. Among which, the brocade figure is most common, and is the main fancy pattern for mass-produced export porcelain, which has been very popular since the middle and late Qing Dynasty.

Technique

Gorgeous Scenes out of Sketching, Tracing and Filling

From the technical point of view, Canton enamel is a kind of product which applies paint on glazed porcelain. Skillful hands bring blossom on Canton enamel with outlining, tracing, weaving and filling.

Canton enamel adopts Chinese brocade patterns, combines various colors and gold and silver solutions in its production of painted porcelain. It employs outlining, tracing, weaving, and filling techniques on glazed white porcelain, as though myriad gold and silver threads woven on white jade, as a verse vividly describes, "Color brushes are the needles and pigments the threads, interlacing threads come out from exquisite needlework. Who needs silk and satin to embroider the spring view? Spring blossoms have already flown onto the silvery porcelain."

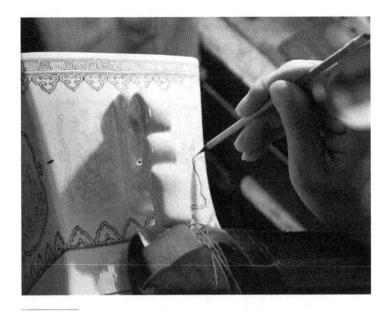

Line drawing

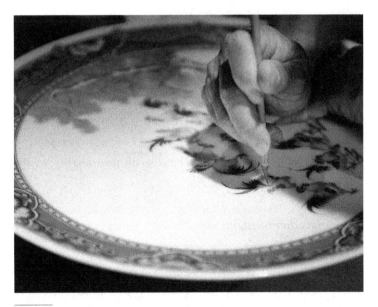

Coloring

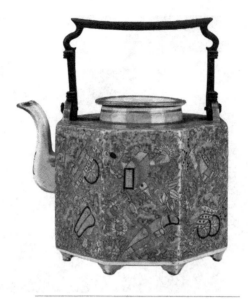

Octagonal porcelain teapot with bronze beam

Its painting technique inherits the Jingdezhen multicolored single-outline flat-coloring painting technique and the multicolored outline-free painting technique (or boneless painting). At the same time it also absorbs western painting method, that is, employing the principle of focal perspective, focusing on the brightness and three-dimensionality of the picture.

The production of traditional Canton enamel is made entirely with hand. The craft process roughly includes porcelain selection, outlining, color filling, weaving and filling, edge sealing and baking. Out of these complex and sophisticated craftsmanship comes the exquisite Canton enamel.

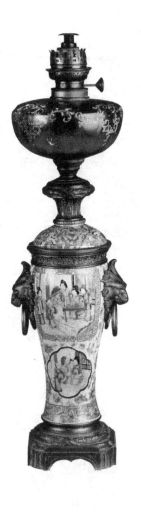

Lamps with the design of figures on copper base (by courtesy of Guangzhou Thirteen Hongs Museum)

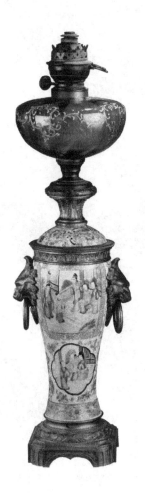

The Inextinguishable Kiln Fire

Inheritance of Cherished Value

Value

Perfect Union of Chinese and Western,
Evolving Techniques

New Look

Conservation of the Craft and
Torch Passing

Value

Perfect Union of Chinese and Western, Evolving Techniques

As the fruition of the exchange between the Chinese and Western civilizations, Canton enamel is unique in its magnificence and splendor. It manifests the characteristics of the integration of Chinese and Western styles in the employment of painting techniques, decorative styles, and use of pigments, which materializes in the technological aspect of bright color, rigorous composition, fine painting workmanship, and dazzling magnificence, which is radically different from ancient porcelain of Chinese tradition. And in response to different historical stages, it assumes different characteristics of the times.

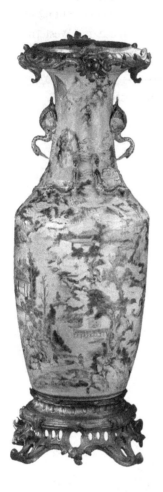

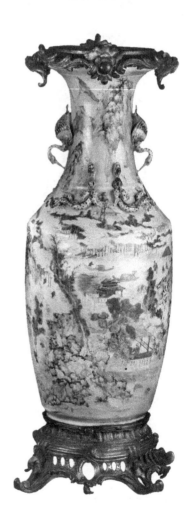

A pair of vases with the design of landscapes and figures inlaid with copper base (by courtesy of Guangzhou Thirteen Hongs Museum)

Early Canton enamel was mainly stand-alone products, and its style was similar to that of enamel painting. It borrowed techniques from Western oil-painting, focused on changes in light and shade, employed bright colors, blended Chinese and Western themes, and customized according to the sample provided by customers. The craft manifested the features of "variegated styles and ingenious crafts, each displaying their respective strength".

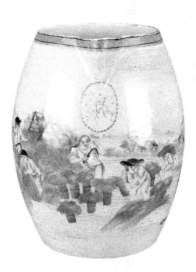

Wine Bottle with the design of western figures in autumn harvest

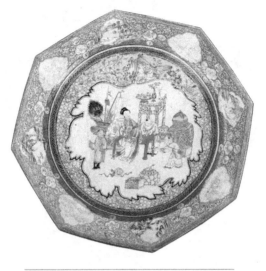

Octagonal porcelain plate with figure paintings

Since the Daoguang period of the Qing Dynasty, Canton enamel style has gradually been stabilized, manifesting established features such as compact composition, complex patterns, and bright colors. The subjects are mostly Lingnan fruits, flowers, birds, fish and insects, scenes from classic literary works and traditional Chinese operas.

While inheriting and maintaining the traditional characteristics, modern Canton enamel acquires new characteristics of the times. It has made quite some innovation in fancy themes, and also conducted new exploration and development in fields of pigments and technology.

New Look

Conservation of the Craft and Torch Passing

| Rebirth
| Recovery and Innovation

Over half century after the founding of the People's Republic of China, Canton enamel has gone through the historical processes of recovery, transformation, inheritance and development.

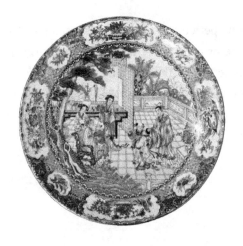

Work of Guangzhou Zhijin Painted Porcelain Factory

In 1956, 35 craftsmen who had been engaged in Canton enamel production in Hong Kong and Macau returned to Guangzhou to establish the "Canton Enamel Factory", which was later renamed "Guangzhou Zhijin Painted Porcelain Factory". Since then, Canton enamel has returned to Guangzhou and been brought back to life. Craftsmen of the new era have made improvements and innovations in fields of pigments, patterns, baking, etc., and explored ways of diversification and reformation.

Since the end of the 1970s, with the improvement of technology and the expansion of the craftsmen team, the variety of Canton enamel product expanded. Because of technical advances such as adoption of techniques including stamping and decalcomania, production volume of Canton enamel saw substantial increase and Canton enamel technique advanced to a new stage.

In the same period, many master craftsmen of Canton enamel were at the prime time of their creative power; many fine art works came out of their hands, such as Zhao Guoyuan's *A Flower Basket Vase of Grand View Garden*, Yu Peixi's *Dragon Ear Vase of Mu Guiying Assuming Commandership*, and Situ Ning's *Phoenix Ear Vase of Birds*.

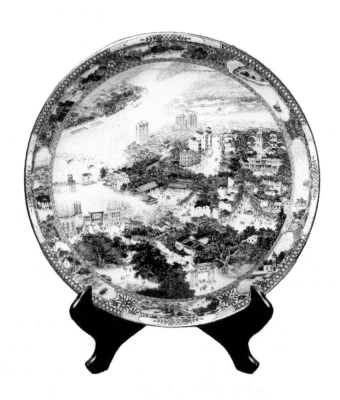

Work of Xu Enfu, a master of arts and crafts in Guangdong Province

Intangible cultural heritage
Regain Past Glory

In the 21st century, like many other traditional crafts, Canton enamel also faces problems such as market transformation, product positioning, and talent training. In 2008, Canton enamel firing technique was placed into the second batch of national intangible cultural heritage list. In 2009, Yu Peixi, an industry-wide recognized master craftsman, was accredited as a national representative inheritor of the craft. Since then, Chen Wenmin, Tan Guanghui, Xu Enfu, Zhai Huiling, He Lifen, Zhao Yiming and other Canton enamel master craftsmen have also been accredited as representative inheritors of Canton enamel firing skills.

While inheriting the tradition, contemporary Canton enamel has gradually turned to the creation and production of fine crafts and artistic crafts, which features more creativity, greater variety of techniques and more powerful expressiveness. In 2017, every Chinese and foreign guest attending the *Fortune* Global Forum in Guangzhou received a gift with rich Guangdong flavor—Canton enamel flower plate titled *Setting Sail*, which is a masterpiece by Tan Guanghui, the national representative inheritor of Canton enamel. The work combines sailing boats with traditional Canton enamel decorative patterns, implying the intersection of history and modernity. Incessant emergence of wonderful contemporary masterpieces bring home to people the charm of Canton enamel once more. This traditional craft, which has gone through hundreds of years of vicissitudes, is now glowing with new brilliance in the hands of more Canton enamel inheritors.

This book is the result of a co-publication agreement between Nanfang Daily Press (CHINA) and Paths International Ltd. (UK)

Title: Canton Enamel: The Charm of Export Porcelain
Author: Elegant Guangdong Series Editorial Board
Hardback ISBN: 978-1-84464-715-6
Paperback ISBN: 978-1-84464-716-3
Ebook ISBN: 978-1-84464-717-0
Copyright © 2022 by Paths International Ltd., UK and by Nanfang Daily Press, China

Paths International Ltd
www.pathsinternational.com

Published in United Kingdom

CPSIA information can be obtained
at www.ICGtesting.com
Printed in the USA
LVHW080807231122
733471LV00001B/1